Pattern Illustrating Patterns

Pattern Language 3.0 Catalogue Series

Learning Patterns: A Pattern Language for Creative Learning

Presentation Patterns: A Pattern Language for Creative Presentation

Collaboration Patterns: A Pattern Language for Creative Collaborations

Words for a Journey: The Art of Being with Dementia

Survival Language: A Pattern Language for Surviving Earthquakes

Change Making Patterns: A Pattern Language for Fostering Social Entrepreneurship

Meta-Pattern Language Catalogue Series

Pattern Illustrating Patterns: A Pattern Language for Pattern Illustrating

Pattern Illustrating Patterns
A Pattern Language for Pattern Illustrating

Takashi Iba
with Iba Laboratory

CreativeShift

Copyright © 2015 by Takashi Iba and Iba Laboratory

All rights reserved. This book or any portion thereof may not be reproduced or used in any manner whatsoever without the express written permission of the publisher except for the use of brief quotations in a book review or scholarly journal.

The authors and publisher have taken care in the preparation of this book, but no liability is assumed for incidental or consequential damages in connection with or arising out of the use of the information contained herein.

First Printing: 2015
V.1.00

ISBN 978-1-329-25383-4

CreativeShift Lab, Inc.
Mizunobu Bldg., 7F, Kitasaiwai 1-11-1, Nishi Ward,
Yokohama, Kanagawa, Japan zip 220-0004
www.creativeshiftlab.com

Pattern Illustrating Project, Iba Laboratory at Keio University
Kaori Harasawa, Natsumi Miyazaki, Rika Sakuraba, and Takashi Iba

Illustrations by Rika Sakuraba, Kaori Harasawa, and Natsumi Miyazaki

*For everyone who wants to live more creative
and helps others live more creative.*

Contents

Acknowledgements	xi
Preface	1
Introduction	**3**
Pattern Language and Visual Aids	5
Pattern Illustrating Patterns	15
How to read Pattern Illustrating Patterns	17
The Patterns	**19**
The Core Patterns	**21**
Pattern Illustrating	22
Essential Message	24
Moving Characters	26
Symbolic Representation	28
Patterns for Drawing Elements	**31**
Center Words Hunting	32
Overall Rough Sketch	34
Sketches of Details	36
Image of Motion	38
Word Association Game	40
Deciding the Amount	42

Patterns for Determining the Scene and Space 45
 Layout of Space 46
 Instinct Direction 48
 Zooming Out 50
 Lively Peak Capture 52
 Acting Illustrator 54
 Time Symbol 56

Patterns for Finishing Touches to Raise the Quality 59
 Mood Unity 60
 Consistent Story 62
 Composition Differentiation 64
 Strangeness Busters 66
 Simple Illustration 68
 Illustration Fans 70

Patterns for Assisting when You are Stuck 73
 Intriguing Doodles 74
 External Inspiration 76
 Third Person View 78
 Polishing Word Sense 80
 Stock of Expressions 82
 Improving by Drawing 84

References 87

A Tale of Pattern Illustrating 91

Acknowledgements

We would like to thank Richard Gabriel, Linda Rising, Joseph Yoder, Rebecca Wirfs-Brock, Jenny Quillien, Lise Hvatum, Bob Hanmer, Mary Lynn Manns, Christian Kohls, and Christian Koppe for encouraging our quest to create a new type of pattern language. We want to thank our shepherd Jason Che-han Yip, and also workshop participants for giving kind comments on the theory and methodology of drawing pattern illustrations at the PLoP2014 conferences. We would like to express our deepest gratitude to Taichi Isaku for his support in translating patterns.

Preface

Recently, the field of pattern language has been developing in various domains. Patterns are usually expressed in sentences, along with a visual expression. One of these expressions is called a "pattern illustration" because it expresses the essence of the pattern, includes characters that express human movements and feelings, and symbolically represents a pattern that does not connect multiple scenes with arrows.

Pattern illustration describes the pattern's primary content, and this helps readers understand and memorize the pattern and also motivates them to use it. But our question here is "How can we draw these pattern illustrations?"

In this book, *Pattern Illustrating Patterns*, we have collected 28 patterns on how and what to draw and what aspects must be considered when creating pattern illustrations.

We hope this book will stimulate further understanding about including pattern illustration as an approach to visual aid by those considering or creating pattern languages.

Introduction

Pattern Language and Visual Aids

In daily life, people learn from various types of experiences. Some of what they learn is worth sharing since others might face similar situations in the future. Over the last two decades, pattern language has been studied as a way to share such practical knowledge. Pattern languages are used to scribe practical knowledge in a target domain, and "practical knowledge" refers to the intelligence both to understand problems and to solve them. In other words, pattern languages describe what types of problems occur in certain contexts, along with what types of solutions or actions can be taken to solve the problems.

 The original idea of using pattern languages to write design knowledge was proposed by architect Christopher Alexander (1979). The book he wrote with his colleagues in the late 1970s comprised 253 patterns on practical architectural design (Alexander et al., 1977). In the context of architecture, pattern language was developed to serve as a lingua franca for architects and residents in designing buildings (Alexander, 1985). Alexander anticipated that people could become involved in the design process for their houses and towns.

 Ten years after the book was published, Alexander's idea of pattern languages was adopted in the field of software design (Beck & Cunningham, 1987; Gamma et al., 1995). By also scribing technical knowledge about software design, pattern language's primary purpose was to diminish the technical gap between experts and the less experienced. Software designers who wished to improve their skills read patterns to learn from the design knowledge of the more experienced programmers (Gamma et al., 1995).

 Since the 1990s, the fields in which pattern languages are applied have greatly expanded, encompassing creative human actions such as

education (Pedagogical Patterns Editorial Board, 2012), organizational change (Manns & Rising, 2005), learning (Iba with Iba Laboratory, 2014a), presentation (Iba with Iba Laboratory, 2014b), collaboration (Iba with Iba Laboratory, 2014c), social innovation (Shimomukai et al., 2015), disaster prevention (Furukawazono *et al.*, 2015), and living well with dementia (Iba *et al.*, 2015), at which point I name these new types of pattern languages "Pattern Language 3.0" (Iba, 2011, 2012). Pattern languages are now used to connect all types of people with all types of different experiences. Patterns aid in underscoring less noticeable parts of experience, so an individual can reconsider an experience, talk about it, and share it with others.

When we examine the history of pattern language, Christopher Alexander first proposed it in architecture, and its methodology was later applied to software design. In both fields, patterns were expressed with sentences and visual aids. There were photographs or diagrams used in architectural patterns, and source codes and screen transition diagrams were used in software design patterns. However, visual aid for human action pattern language is still unclear on its definitions and methodology. This book introduces pattern illustration as the visual aid of pattern languages for human actions, namely Pattern Language 3.0, and *Pattern Illustrating Patterns* to support its creation. Pattern illustration is defined as follows:

1. It expresses the pattern's essence.
2. It includes character(s) that express human movements and feelings through body language and facial expressions.
3. It symbolically represents a pattern that does not connect multiple scenes with arrows.

An illustration that meets these three requirements is "pattern illustration." Figure 1 shows examples of characters in pattern illustrations.

Figure 2-4 demonstrate pattern illustrations from the Presentation Patterns, which is the pattern language for creative presentations (Iba with Iba Laboratory, 2014). Figure 5-7 show pattern illustrations of Collaboration Patterns, which is the pattern language for creative collaboration (Iba with Iba Laboratory, 2014).

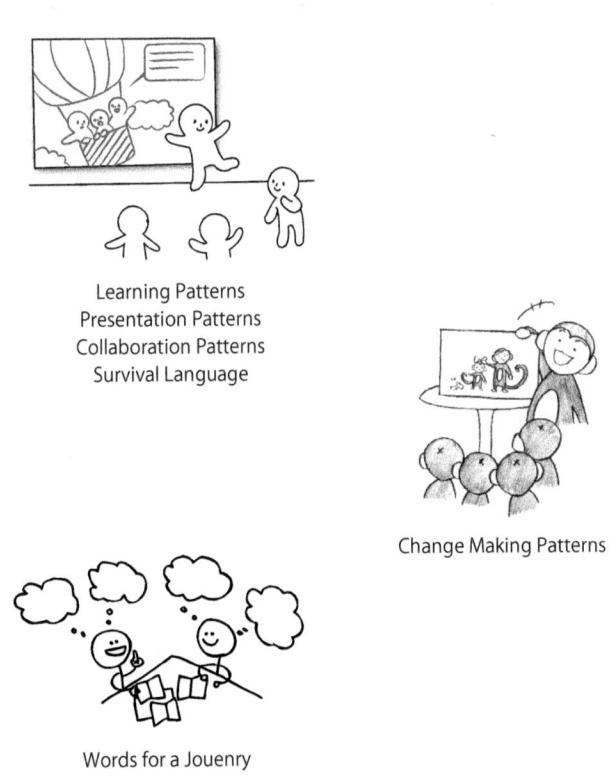

Learning Patterns
Presentation Patterns
Collaboration Patterns
Survival Language

Change Making Patterns

Words for a Jouenry

Figure 1: Several characters in pattern illustrations

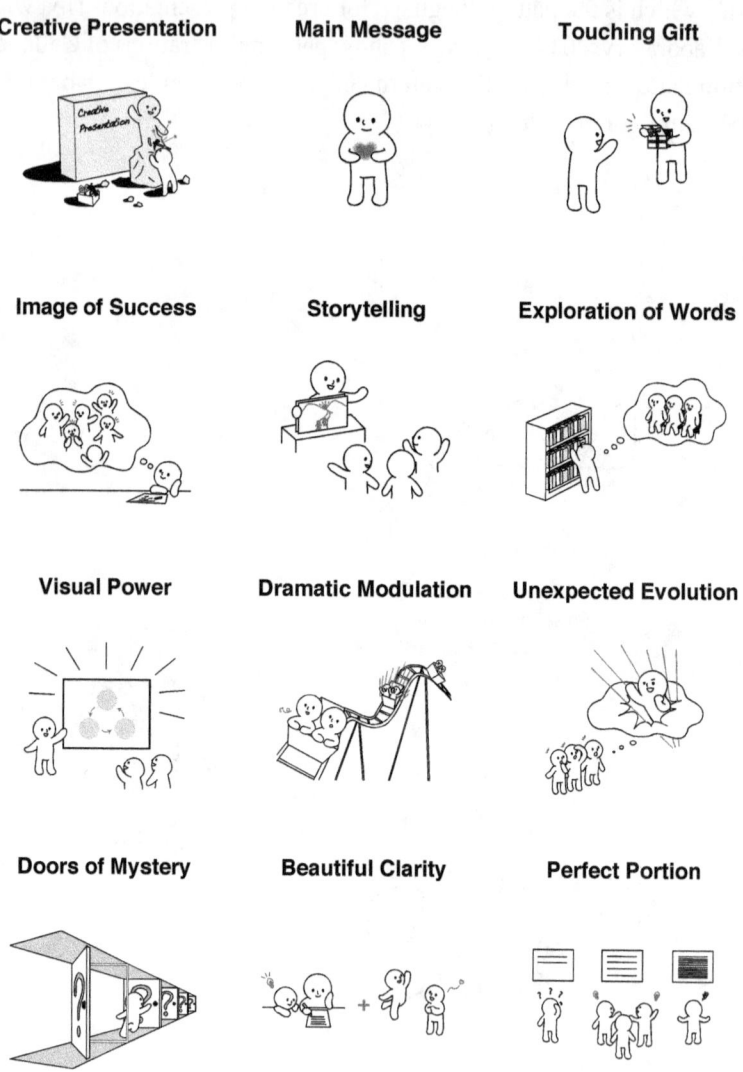

Figure 2: Pattern illustrations of the Presentation Patterns (1/3)

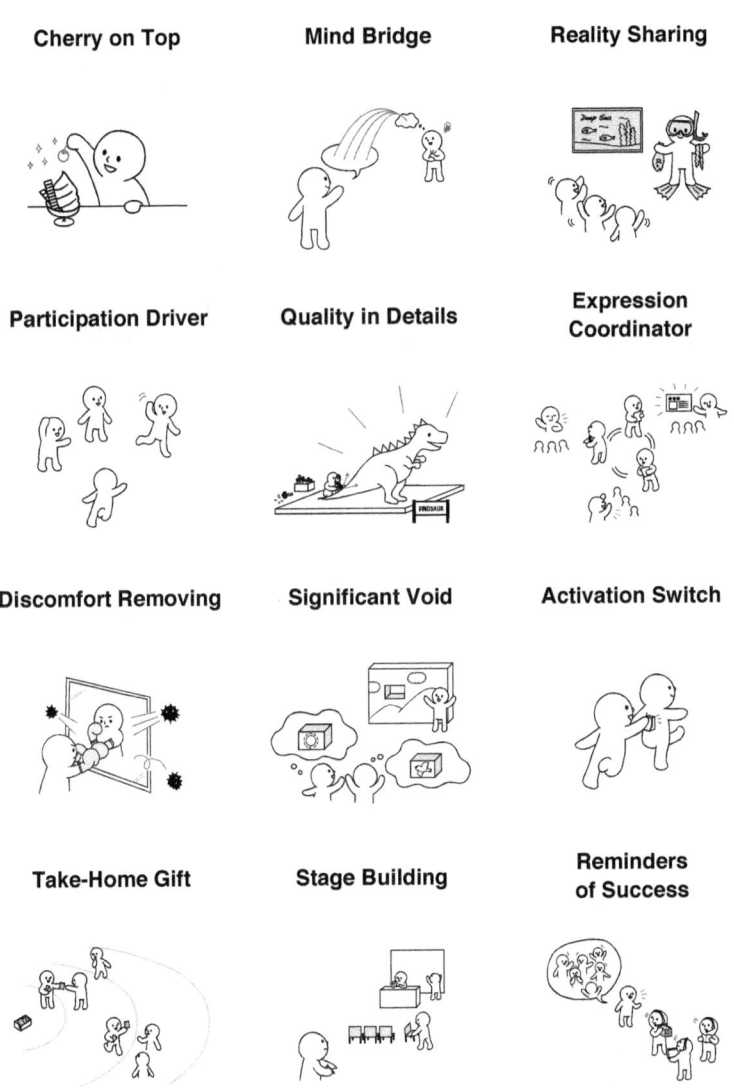

Figure 3: Pattern illustrations of the Presentation Patterns (2/3)

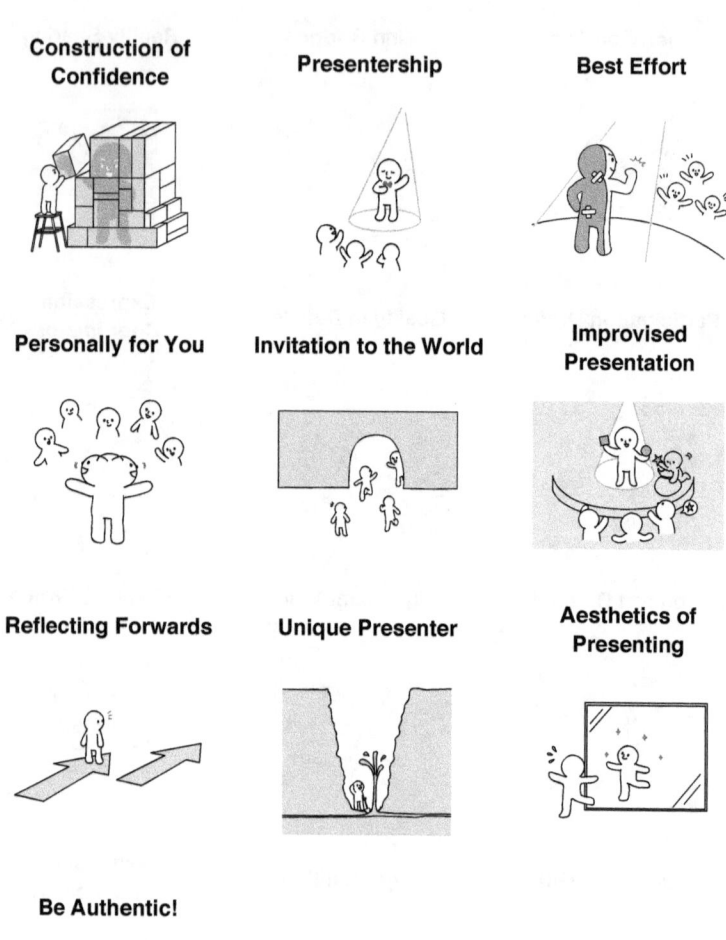

Figure 4: Pattern illustrations of the Presentation Patterns (3/3)

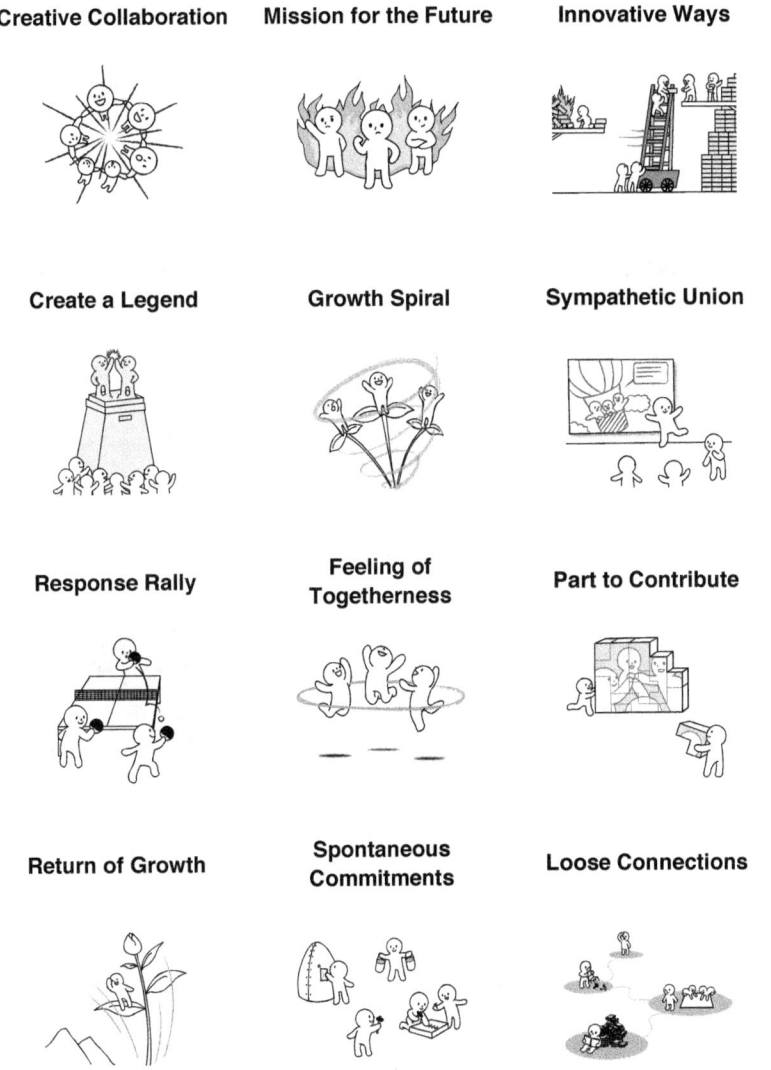

Figure 5: Pattern illustrations of the Collaboration Patterns (1/3)

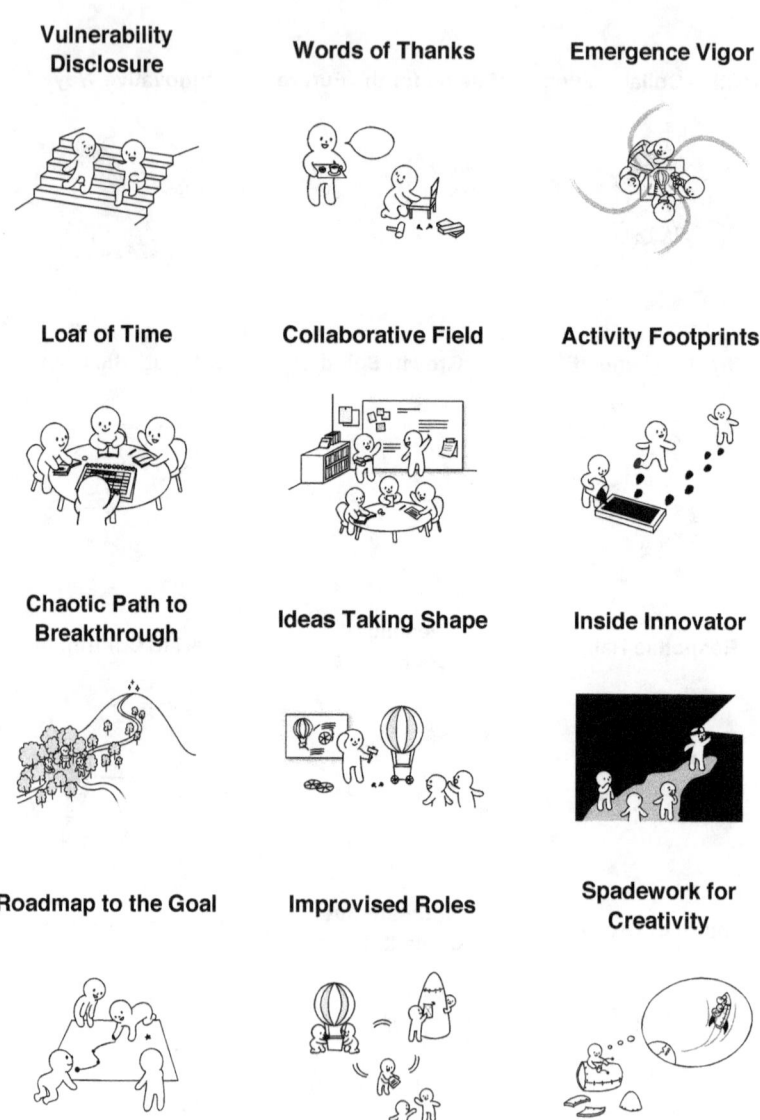

Figure 6: Pattern illustrations of the Collaboration Patterns (2/3)

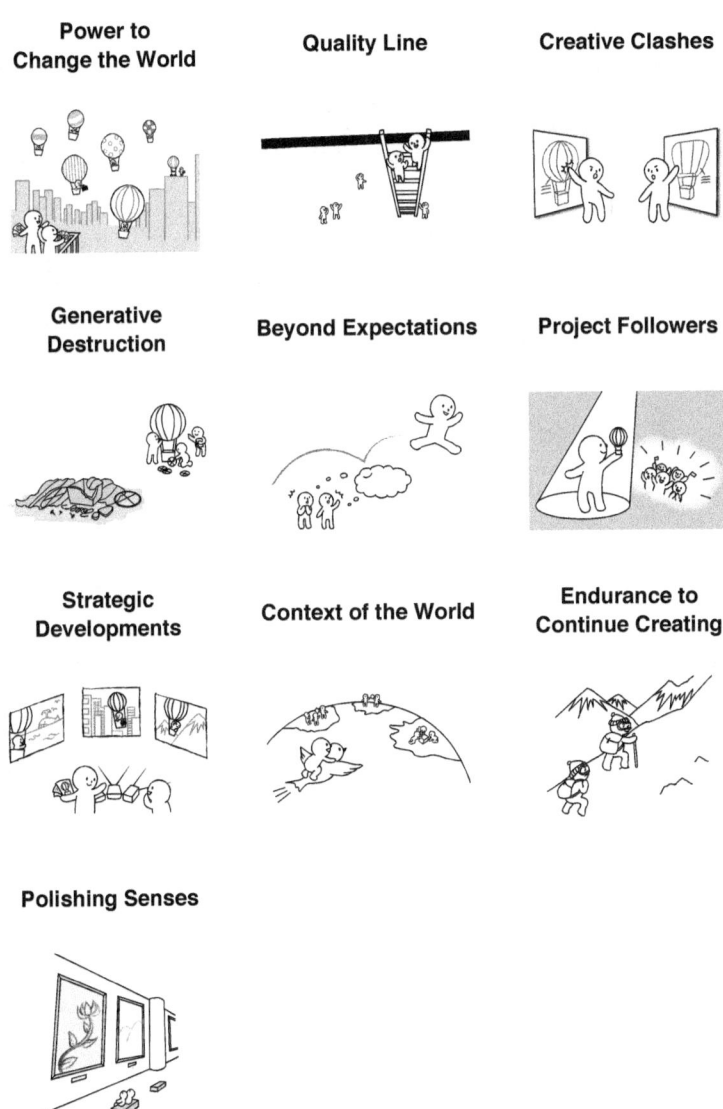

Figure 7: Pattern illustrations of the Collaboration Patterns (3/3)

The picture book: A Tale of Pattern Illustrating (Harasawa, *et al.*, 2015) is recommended as preliminary reading for the Pattern Illustrating Patterns. The book narrates the pattern illustrating process in the form of a story to provide a deeper understanding of the patterns. Details of the picture book are given at the end of this book.

Figure 8: A picture book, *A Tale of Pattern Illustrating*

Pattern Illustrating Patterns

Pattern Illustrating Patterns are patterns for how to draw pattern illustration. A good pattern illustration helps readers understand and memorize the pattern and also motivates them to use it.

This book contains 28 patterns for pattern illustrating. It begins with pattern No. 0, *Pattern Illustrating*, that introduces pattern illustration, and three patterns, No. 1 Essential Message, No. 2 *Moving Characters*, and No. 3 *Symbolic Representation*, follow to define it specifically.

Then, the main three phases, "drawing elements" (Nos. 4–9), "determining the scene and space" (Nos. 10–15), and "finishing touches to raise the quality" (Nos. 16–21) are each supported with six patterns.

The last set of patterns concludes with "assisting when you are stuck," which includes No. 22 *Intriguing Doodles*, No. 23 *External Inspirations*, and No. 24 *Third Person View* ("things you should care about in daily life"), No. 25 *Polishing Word Sense*, No. 26 *Stock of Expressions*, and No. 27 *Improving by Drawing*—all adding up to 28 patterns.

Please keep in mind that these patterns assist you with drawing pattern illustration, but do not tell you exactly and precisely what to do. These patterns introduce solutions to problems you are likely to face while drawing. By combining these patterns according to your needs, you should be able to produce good pattern illustrations.

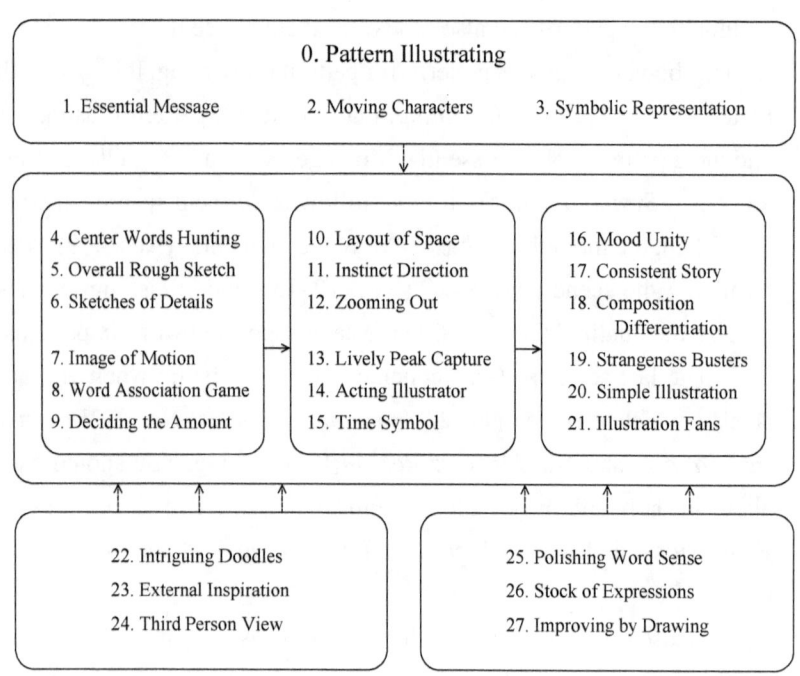

How to read Pattern Illustrating Patterns

The patterns in this book are all written in the same format. From the top left of the page: pattern number, pattern name, and pattern illustration. The top left expresses pattern number, and next is pattern name. The name gives the pattern a short, memorable name that describes the pattern, so that it can be easily referenced. Pattern illustration serves to help readers get a lively image of the pattern. From the bottom left to the right of the page: Context, Problem, Forces, Solution, Actions, and Consequences.

First, the Context or the situation in which this pattern should be used is described. Followed by that, a Problem likely to occur is written. The Forces underneath the Problem are unavoidable laws of human nature that make the problem difficult to overcome.

Then come the word "Therefore" and the Solution in bold type. Actions are better for explaining rather abstract solutions, using concrete Actions that readers can take. The Consequence describes how things should change when this pattern is properly applied to drawing pattern illustration. And lastly, Related Patterns are introduced.

The Patterns

The Core Patterns

Nos. 0 - 3

0 Pattern Illustrating

1 Essential Message
2 Moving Characters
3 Symbolic Representation

No.0

Pattern Illustrating

You are writing the pattern description.

▼ In this context

You have something to tell through the pattern, but it's hard to make it understandable and appealing to readers. Patterns for human action encourage real change and suggest new perspectives. To achieve this goal, you should explain the pattern in detail. However, long descriptions confuse readers with their complexity, while short descriptions do not fully explain the pattern's contents.

▼ Therefore

Draw Pattern Illustrations to express the pattern visually. Pattern Illustration is the pattern's *Essential Message*, and it is also a *Symbolic Representation* of illustration, in which *Moving Characters* appear. To draw these, use patterns from Pattern Illustrating Patterns. For the main flow, do *Center Words Hunting* to grasp the pattern's essence, and draw the *Overall Rough Sketch, Layout of Space,* and *Lively Peak Capture* to express the pattern as lively literature.

▼ Consequently

When patterns are introduced visually, readers can easily imagine the pattern's broad picture and read the sentences with interest. Visual expressions also leave an impression on readers' minds, and this supports their recall of the pattern. Moreover, compared to pattern sentences, pattern illustration better depicts the pattern's "life," stirring readers' excitement and motivation.

▷ 1. Essential Message ▷ 2. Moving Characters
▷ 3. Symbolic Representation ▷ 4. Center Words Hunting
▷ 5. Overall Rough Sketch ▷ 10. Layout of Space ▷ 13. Lively Peak Capture

No.1

Essential Message

You want to draw pattern illustration.

▼ In this context

The illustration will only be something extra for the sentences or just a figure unless it describes the pattern's content. Each pattern description includes a Context, Problem, Solution, and Consequence. These elements should also be presented in the illustration describing the pattern content. If only some elements are presented, the pattern illustration cannot stand alone and will be just a supplement to the description.

▼ Therefore

Consider pattern illustration as having the same value as the pattern description; try drawing an illustration that contains the pattern's essence. These essences are expressed in the pattern description, in what we call "center words." First, try *Center Words Hunting* when starting to draw the pattern illustration. You may find center words anywhere in the pattern description, not only in the solution. By collecting center words, you can recognize what needs to be drawn.

▼ Consequently

Similarly to the pattern description, the pattern illustration includes the pattern's essential message. As a result, readers can easily remember the pattern just by the pattern name and illustration. Readers may recall the illustration in their daily lives, triggering the pattern content, and thus the illustration will help them use the pattern.

▷ 4. Center Words Hunting

No.2

Moving Characters

You want to draw a pattern illustration that expresses
the pattern's *Essential Message*.

▼ In this context

Drawing only the pattern's context cannot express how the reader should act and the consequences. Even if you draw the pattern's scenery or key object, the reader won't know what kind of action to take and why the pattern is important. If you can't help readers understand these two elements, you haven't succeeded in drawing the pattern's *Essential Message*.

▼ Therefore

Draw a character that embodies the pattern's *Essential Message*. Pattern functions as a tool showing readers how to solve a problem in a particular context. So use a character to express what kind of action to take to solve the problem. By drawing a character, you can express actual movements, facial expressions, and emotions such as excitement. Also, it's better if you can create a simple character—these are easy to draw and look friendly to readers.

▼ Consequently

Through the character's expressions, you can show readers what to do or potential consequences after taking action. Readers may be able to understand the pattern by projecting themselves into the character's motions and expressions.

▷ 1. Essential Message

No.3

Symbolic Representation

You want to draw a pattern illustration that expresses the pattern's *Essential Message* by presenting *Moving Characters*.

▼ In this context

Multiple scenes provide too much information for readers to focus on the pattern's *Essential Message.* Pattern language for human action transforms individuals or communities to a positive state. In such a process, it is natural to describe the transition visually. However, connecting some scenes only with arrows or presenting them comic style would require readers to interpret or judge patterns, thereby preventing their intuitive apprehension.

▼ Therefore

Draw the scene that solves the problem within the context. Pattern illustration should inspire readers to instantly recognize possible solutions. So describe the scene that solves the problem, rather than the problem itself. This helps emphasize the solution, which is the consequence of solving the problem. Also, by introducing *Moving Characters* to add vivid and emotional elements, the illustration may include a sense of there being potential good results.

▼ Consequently

The illustration will symbolically represent the pattern, consisting of the pattern's *Essential Message* and action suggestions. This way, you can depict a pattern illustration that shows the *Essential Message* constructed with elements of context, problem, solution, and consequence. Readers will be encouraged to use the pattern when attractive expressions are used in the illustration.

▷ 1. Essential Message ▷ 2. Moving Characters

Patterns for Drawing Elements

Nos. 4 - 9

4	Center Words Hunting
5	Overall Rough Sketch
6	Sketches of Details
7	Image of Motion
8	Word Association Game
9	Deciding the Amount

No.4

Center Words Hunting

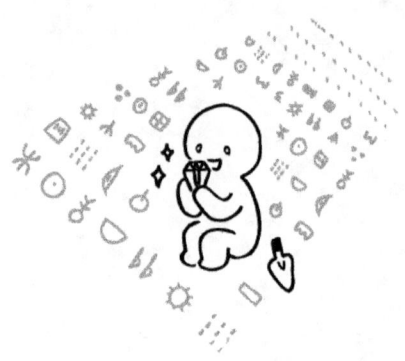

You are going to draw the pattern illustration.

▼ In this context

Drawing all of the pattern's elements doesn't express the pattern's essence. Patterns for human action are constructed with Context, Problem, Solution, and Consequence. This information includes what readers should do, when readers should act, how readers might feel using the pattern, and so on. However, if you draw all this information, readers won't be able to grasp the pattern's meaning.

▼ Therefore

Identify essential strong words or phrases to grasp the pattern's essence. We call these words or phrases "center words." Center words appear mostly in the Solution and Consequence, but they are also found in Problem and Context, so read the whole pattern several times. Also, the pattern description isn't always perfect, so reconsider suitable words that best describe the pattern. Communicate with the pattern writer to find out what he/she most wants to tell readers or try to describe the pattern in your own words.

▼ Consequently

You will be able to discover and express *Essencial Message* that compose the pattern and transform them into illustrations. Also, while you address the pattern content in various ways, you might detect more suitable words for the pattern. *Polishing Word Sense* is important for good hunting of center words.

▷ 1. Essential Message ▷ 25. Polishing Word Sense

No.5

Overall Rough Sketch

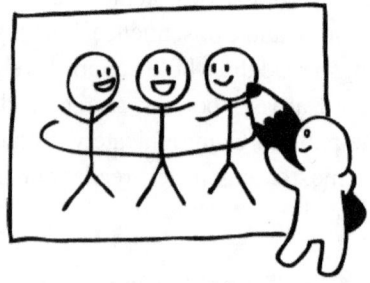

You are drawing an illustration using words or phrases discovered during the process of *Center Words Hunting*.

▼ In this context

Just visualizing each center word won't give the illustration wholeness. Not considering how the center words are related will provide only "parts" of what needs to be drawn. Even if you pile up a bunch of parts, that won't create wholeness. To construct an illustration with wholeness, you need to think deeply about the connections among the center words.

▼ Therefore

Draw a rough sketch of the pattern illustration while you imagine what it should be like as a whole—according to the relationship between center words. Try drawing a rough overall sketch of the illustration instead of drawing detailed parts. There's no need for you to draw it perfectly at first, just draw it roughly to catch its entire image. At this stage, draw a stick man instead of a detailed character.

▼ Consequently

You can draw the pattern's lively atmosphere, which can't be captured by piling up a bunch of parts. Also, moving your hand, rather than just thinking, leads to *Intriguing Doodles*, which can in turn inspire your drawing.

▷ 4. Center Words Hunting ▷ 22. Intriguing Doodles

No.6

Sketches of Details

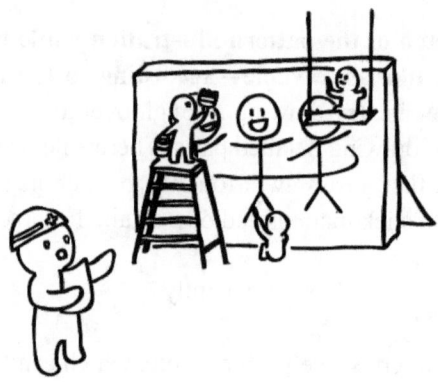

You are drawing an illustration using the *Overall Rough Sketch*.

▼ In this context

You can't put detailed shades of information in the illustration. The *Overall Rough Sketch* allows you to draw the illustration only broadly. Notice that this rough sketch does not fully describe the pattern's details.

▼ Therefore

Add elements that are lacking and adjust parts to strengthen the illustration's attraction for readers. Pattern illustration should describe the pattern independently. So look at the illustration drawn in the *Overall Rough Sketch* and read the written pattern to ensure that the two don't contradict one another. On that basis, adjust the illustration and add those missing elements necessary to describe the pattern with *Deciding the Amount* of elements.

▼ Consequently

Your illustration will become more detailed, and it will include the important elements required by readers. From the *Overall Rough Sketch*, you can decide on precise parts, like a character's movements and facial expressions.

▷ 5. Overall Rough Sketch ▷ 9. Deciding the Amount

No.7

Image of Motion

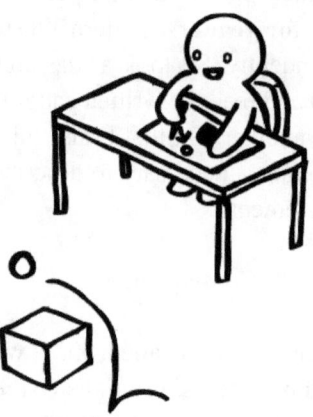

You are thinking about how to visualize the center words that describe motion.

▼ In this context

It's difficult to visualize center words like "getting closer" or "jump over" that describe the pattern's motion. To visualize these words, you need to acknowledge what is moving. For example, for you to draw "jump over" in the illustration, you need to know what is jumping over what kind of object. Human behavioral patterns may contain center words that can't be drawn easily, preventing you from drawing the *Overall Rough Sketch*.

▼ Therefore

Use simple figures or arrows to express the motion's image. For now, you can leave out what is moving. So for the time being, use figures like circles, squares, and so on to express an object and use arrows to show in which direction it is moving. At this stage, the most important thing for a successful illustration is seeing the motion's image.

| jump over | getting closer | jump in | gather attention | add slightly | involve |

▼ Consequently

You can draw an *Overall Rough Sketch* that contains center words expressing motion. Also, it helps to think of a metaphor or a scene of the illustration. For example, when there's a center word like "add slightly," you can draw an image of adding something small to something bigger. When you draw this with simple figures and arrows, it helps if you think of a metaphor like "the cherry" (something small) "on top of a parfait" (something bigger).

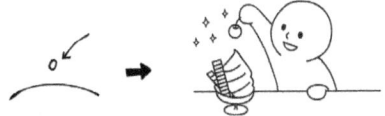

▷ 5. Overall Rough Sketch

No.8

Word Association Game

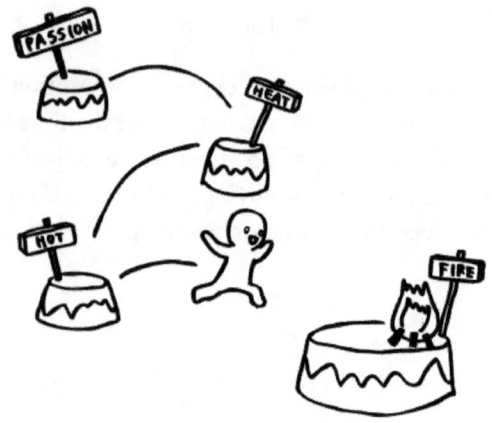

You are trying to visualize center words that describe concepts while drawing the *Overall Rough Sketch*.

▼ In this context

Abstract words like passion, idea, and information cannot be drawn because they don't take any specific shape. Pattern language for human action contains concepts like "passion," "idea," and "information". However, these words don't have a specific shape, preventing you from drawing an important pattern concept.

▼ Therefore

Play a word association game to find the image that best expresses the concept. For example, the word "passion" is associated with heat, and heat can be described by fire. The word association game will lead you to think of something that exists in the real world that can make readers imagine the concept. If you get stuck in the word association game, try using *External Inspiration*.

▼ Consequently

You'll be able to describe the concept in the pattern illustration. You should have *Third Person View* to check whether the word you've come up with actually gives an image of the concept you want to describe. *Polishing Word Sense* is important for good word association game.

▷ 5. Overall Rough Sketch ▷ 23. External Inspiration
▷ 24. Third Person View ▷ 25. Polishing Word Sense

No.9

Deciding the Amount

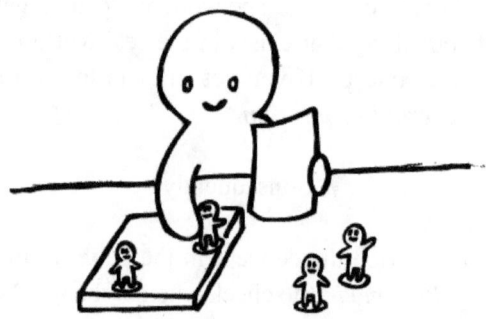

You are working on *Sketches of Details*,
and you are about to decide the amount of information
or the number of characters to include in the illustration.

▼ In this context

No center words refer to numbers or amounts, so you do not know how many of each element to draw in the illustration. When doing the *Overall Rough Sketch*, we tend not to worry about these details. However, the actual pattern illustration will have to give a clear image of the context in which the pattern can be used. If you can find center words that refer to these numbers or amounts, for instance, "many" or "by yourself," it is easy to decide, but this is not always the case.

▼ Therefore

Imagine specific situations in which the pattern will be used to decide the number or amount of elements to draw. Look for words that refer to the conditions of elements—"scattered," "one by one," "each other"—to help you imagine the situation. For example, if something is to be scattered, you know that you will need to draw at least three elements with some space between them. If something is done to "each other," you will need to draw two elements each taking some action toward the other.

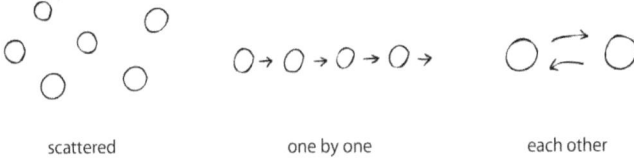

scattered　　　　　　　one by one　　　　　　each other

▼ Consequently

You can decide the number of characters or the amount of objects to draw even without a clear center word. In addition, once information about the number of elements becomes clear through pattern illustration, the information can be added to the pattern description itself to improve the pattern.

▷ 5. Overall Rough Sketch　▷ 6. Sketches of Details

Patterns for Determining the Scene and Space

Nos.10 - 15

10 Layout of Space
11 Instinct Direction
12 Zooming Out

13 Lively Peak Capture
14 Acting Illustrator
15 Time Symbol

No.10

Layout of Space

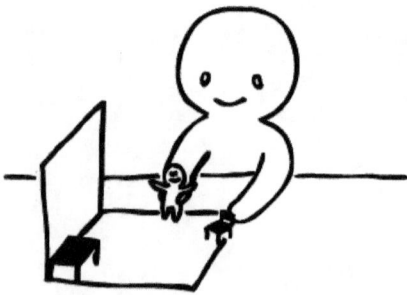

You already know which elements to draw
from the *Overall Rough Sketch* and *Sketches of Detail*.

▼ In this context

The character's action does not look real. A human action pattern should have *Moving Characters* to show readers how to act in the pattern. However there's a huge gap between a character drawn in two dimensions (2D) and readers who can move around in three dimensions (3D), thus leading readers to perceive the character's action as unreal.

▼ Therefore

Draw the illustration as if you are coordinating the 3D space. Even though you are drawing on paper, determine the characters and objects' placement in 3D by imagining how the action would happen in the real world. Also, it's even better if you can draw characters and objects in 3D to show the illustration's depth.

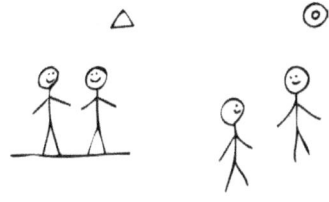

▼ Consequently

You will be able to draw an illustration that looks real. This will lead readers to imagine what action to take. Also, by imagining the real situation, you can draw the space without any awkwardness in the positioning of objects and characters, leading to *Strangeness Busters*.

▷ 2. Moving Characters ▷ 5. Overall Rough Sketch
▷ 6. Sketches of Details ▷ 19. Strangeness Busters

No.11

Instinct Direction

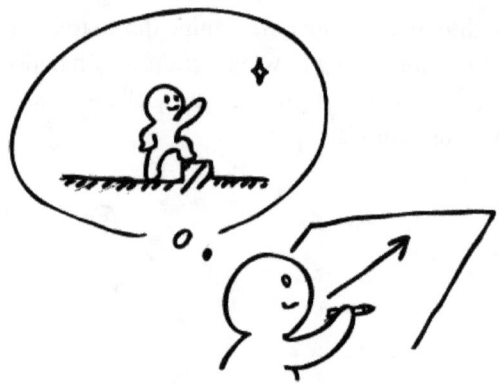

The *Layout of Space* of the pattern illustration,
which describes the pattern's contents, is starting to become clear.

▼ In this context

It's hard to decide on a good illustrative angle that will effectively convey the pattern's message. When drawing an illustration, you will have to choose one point of view and draw the whole illustration from that angle. However, if the situation can be drawn from any angle, establishing this point of view becomes difficult.

▼ Therefore

Choose an angle for drawing the illustration that matches natural physical sensations. We tend to form concepts and images based on physical experiences. For example, when we hear the word growth, we naturally imagine something extending upward—from our experience of growing up ourselves. Similarly, if something is "exploring," the illustration should be drawn from an angle that shows a character headed toward the deeper, inner parts of some area. If a pattern looks to the "future," it should show something moving from the bottom left to the top right. Lakoff and Johnson's *Metaphors We Live By* (1980) is a good reference on this relationship between words and images.

▼ Consequently

If the illustration's composition reflects our natural experiences, it will help readers recall their physical experiences. Such an effect will help them better understand the pattern and help them practice it in their daily lives.

▷ 10. Layout of Space

No.12

Zooming Out

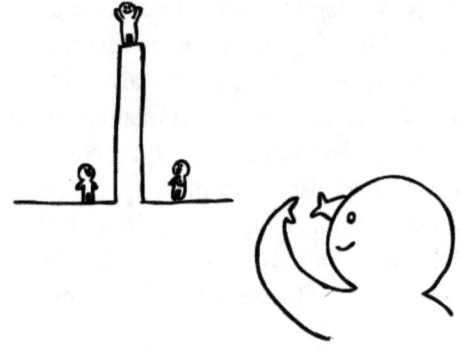

You are doing *Layout of Space*
in order to draw a spatial illustration.

▼ In this context

It's hard to draw velocity or the relative size of objects effectively in the space you have. Since in most cases, patterns and pattern illustrations are written in words to be shared through paper documents or on the Web, there are some limitations to the area the illustration can cover. When drawing an object that is "fast" or "large," you will have to draw its attributes based on comparison. However, with limited space, it's hard to emphasize comparison.

▼ Therefore

Zoom out to capture a wider area so that you can emphasize based on comparison. Imagine you are holding a camera, and you notice the camera can't capture the entire scene. You would probably take some steps back to capture a wider area. Similarly, you can draw a wider area in the illustration, making characters and objects relatively smaller. In the extra space that becomes available, draw in objects of comparison to emphasize difference. For example, if you want to draw a car traveling at high velocity, you can draw in a second car way behind the first to show the different distances that the two cars have traveled in the same time. By drawing a long road and two relatively small cars within the area, you can show the comparison.

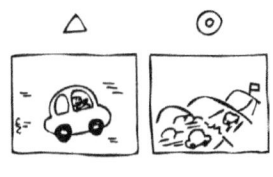

▼ Consequently

You will be able to draw a wide area even within a limited space. By drawing objects of comparison in extra space, you are able to show large or fast objects. In addition, drawing illustrations from a zoom-out point of view will differ from other illustrations and result in *Composition Differentiation*.

▷ 10. Layout of Space ▷ 18. Composition Differentiation

No.13

Lively Peak Capture

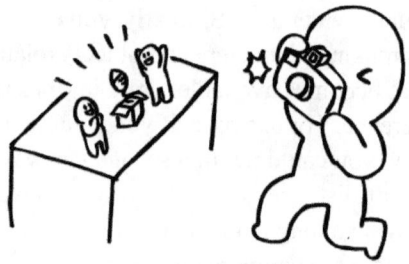

You already know which elements to express from drawing the *Overall Rough Sketch* and *Sketches of Details*.

▼ In this context

You can't express the pattern's lively atmosphere. If a character in the pattern looks lively, the reader may want to use the pattern. When you think about capturing lively moments with a camera, the most important thing is to time pushing the shutter button. In the same way, an illustration's liveliness depends on the captured scene.

▼ Therefore

Imagine time flowing in the pattern and trim the peak of the character's liveliness and excitement. Along the axis of time in the pattern, think, "Which scene best expresses the most lively scene." For example, whether the character's mouth is open or closed, whether the character is trying to run, or is running, and so on. Explore the motions or facial expressions that appeal to readers and decide which scene to trim.

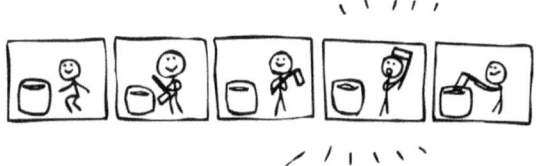

▼ Consequently

You will be able to draw an illustration that projects the pattern's lively atmosphere. A character's facial expressions and motions represent that atmosphere. Such details will motivate readers to use the pattern.

▷ 5. Overall Rough Sketch ▷ 6. Sketches of Details

No.14

Acting Illustrator

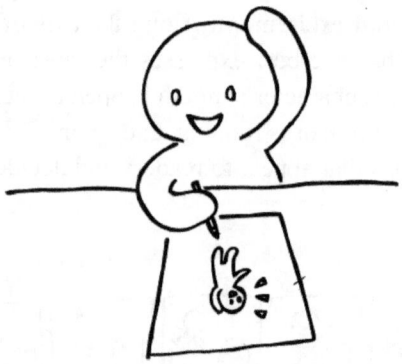

You are doing *Lively Peak Capture*,
and you are trying to capture the pattern's lively action.

▼ In this context

The characters' expressions seem the same in all the patterns, and the illustrations seem to lack reality. Because we try to make characters in the illustration lively, we tend to make them seem happy and put smiles on their faces. However, since the aim of the whole illustration goal is to be lively, all the characters end up with the same expression. In real life, we all express happiness differently, and this reality gap makes readers suspicious.

▼ Therefore

Put yourself in the characters' shoes and act out their roles to get a better image of how their expressions would really look. First, imagine yourself in each character's situation. Ask yourself how you are feeling, what you are about to say, what action you are about to take, or what expressions you are about to make. Don't be shy! Express yourself to get to the reality.

▼ Consequently

By getting first-hand experience with the characters' situations, you will be able to imagine and draw characters with lively expressions. In addition, by really acting out the characters, you might notice unnatural points in your illustration. On these points, you can do *Strangeness Busters* and fix them.

▷ 13. Lively Peak Capture ▷ 19. Strangeness Busters

No.15

Time Symbol

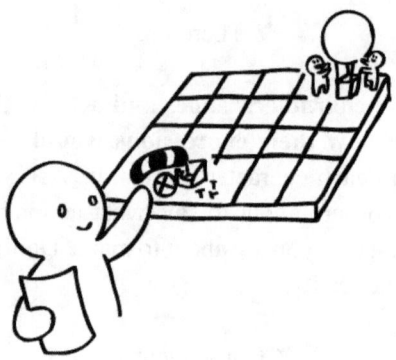

You are drawing your pattern illustration to make it
a *Symbolic Representation*.

▼ In this context

You drew the pattern's solution scene, but the scene itself does not completely convey the pattern's message. Pattern illustrations depict a scene where "an action is being taken to solve a certain problem occurring in a context," becoming a *Symbolic Representation*. However, for some patterns—those showing the ups and downs of a person's life or someone being able to do something they couldn't do before—the passing of time becomes an important factor. For these patterns, the pattern illustration must include both Problem (past) and Solution (present), or both Solution (present) and Consequence (future).

▼ Therefore

Draw the most important scene as the illustration's main part, but include something that symbolizes the past or the future. First, think which scene in the sequence of events is most important for the pattern. Then draw an object or situation that hints at the problems that occurred in the past or at good events about to happen in the near future. Taking examples from Collaboration Patterns, the pattern "Generative Destruction" says to "Take apart what the team has now and make a fresh start to re-create the product," so the illustration shows the very recent past when the previous product version was taken apart. The pattern "Chaotic Path to Breakthrough" advises thinking through troublesome situations thoroughly, expecting a breakthrough in the near future. The illustration expresses the present chaotic situation as a forest and hints at the hidden path leading to the mountaintop.

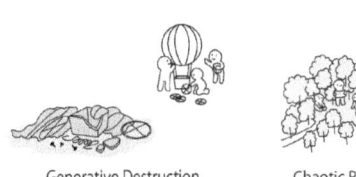

Generative Destruction Chaotic Path to Breakthrough

▼ Consequently

You will be able to draw the passing of time effectively and still maintain the illustration as a *Symbolic Representation*. This kind of illustration hints about what has happened in the past and what will happen in the future. Readers will get a better image of how their situations might change and thus have increased motivation to practice the pattern.

▷ 3. Symbolic Representation

Patterns for Finishing Touches to Raise the Quality

Nos.16 - 21

16 Mood Unity
17 Consistent Story
18 Composition Differentiation

19 Strangeness Busters
20 Simple Illustration
21 Illustration Fans

No.16

Mood Unity

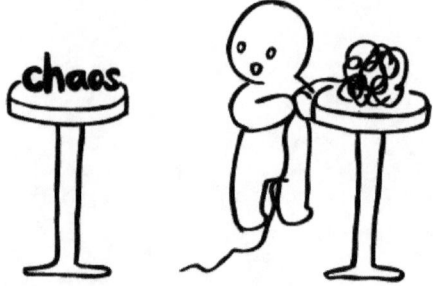

You have finished drawing a pattern illustration.

▼ In this context

Some slight differences between the illustration's nuances and the pattern's name are making the pattern hard to remember. A word conveys not only a meaning, but also expresses the atmosphere and images with which that word is associated. For example, the word "impact" is associated with a spiky image, and the word "complex" is associated with something tangled and chaotic. If these images don't match the actual pattern illustration, readers will be confused about the pattern's true image and get a confused impression of the pattern.

▼ Therefore

Adjust the image of the pattern name and the illustration so that they match. Check for center words and remind yourself of the pattern's true meaning. See whether the pattern name or the illustration is closer to this image and adjust the other so it matches. You will have to rely on your sense of words for this process, so make sure you have a rich *Stock of Expressions*.

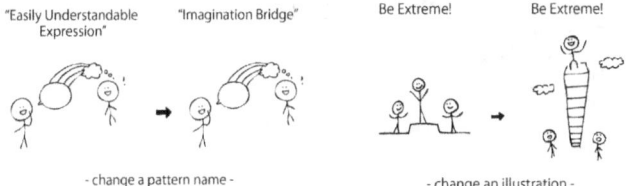

If a metaphor is used in either of the two, make sure this metaphor also matches.

▼ Consequently

The pattern name and the pattern illustration will match perfectly, capturing the pattern's meaning well. The pattern name and illustration will affect readers as a set, conveying the message in a memorable way.

▷ 26. Stock of Expressions

No.17

Consistent Story

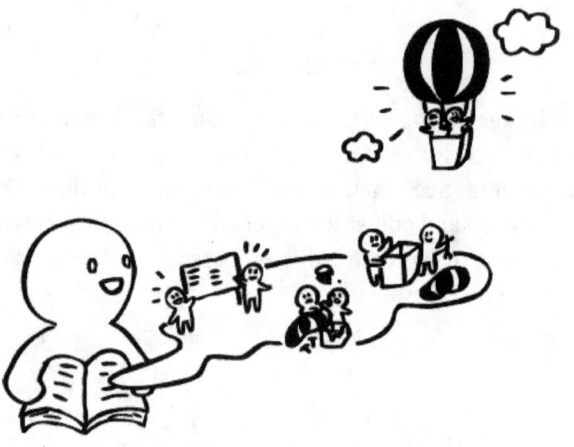

You have finished drawing a couple of pattern illustrations from a pattern language.

▼ In this context

The illustrations' situations have no connections and no unity as a pattern language. Even if each pattern illustration is by itself sufficient to convey one pattern's meaning, individual illustrations may not fit the rest of the illustrations. Say, for instance, there was a pattern language for product design, and in one pattern, characters were designing a hot air balloon, in the next creating a rocket, and in the third, making yet another kind of vehicle. Such lack of unity will raise unnecessary questions in readers' minds and steer their attention away from the pattern's actual meaning. Although patterns are written as a language, such separateness in illustrations will distract from an overall unified viewpoint.

▼ Therefore

Imagine a story having to do with your pattern language's topic and use consistent motifs to draw different scenes from the same story. Choose one theme or motif to become an example for your pattern illustrations. When considering the pattern illustration, imagine how the pattern's situation would be with the chosen theme. For example, in Collaboration Patterns, although the patterns can be applied to any project for creating a product, we decided to use the story of a team creating a hot air balloon to give the illustrations consistency.

▼ Consequently

When pattern illustrations are drawn on the same theme, the pattern language will start to tell a story. Even if individual pattern illustrations each depict a different scene, readers will be able to imagine, within the context of the ongoing story, the overall pattern. In addition, with a constant motif, readers will be able to imagine relationships between patterns. However, keep *Composition Differentiation* in mind since these illustrations can start to look similar.

▷ 18. Composition Differentiation

No.18

Composition Differentiation

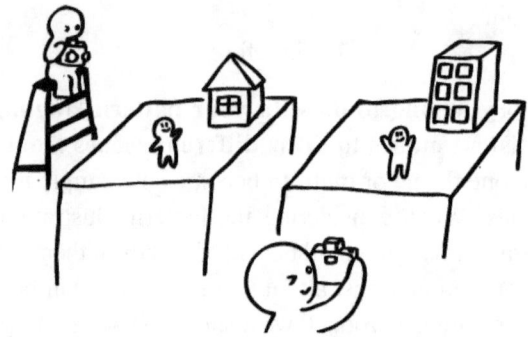

You have finished drawing a couple of pattern illustrations from a pattern language.

▼ In this context

At a glance, a couple of illustrations look similar. You might have been too careful about telling a *Consistent Story*, or the pattern language might have quite a specific theme, and the same objects keep showing up across multiple illustrations. When this happens, it's likely that the same scene is used for multiple illustrations. When drawing illustrations, you work on them one by one, so you are not usually thinking about the similarity of one to the others. In addition, once you start to develop your style as an illustrator, due to habit, you unconsciously tend to draw illustrations from similar angles.

▼ Therefore

From illustration to illustration, change the point of view to give their compositions variety. Be conscious of *Layout of Space* and shift your point of view right, left, up, or down 90 or 180 degrees to see whether there is any other feasible composition. You can also try *Zooming Out* or zooming in from a scene.

▼ Consequently

You can make similar or confusing pattern illustrations distinguishable so that each stands out. Then, readers will not attribute the wrong illustration to a pattern, and each pattern will become more memorable.

▷ 10. Layout of Space ▷ 12. Zooming Out ▷ 17. Consistent Story

No.19

Strangeness Busters

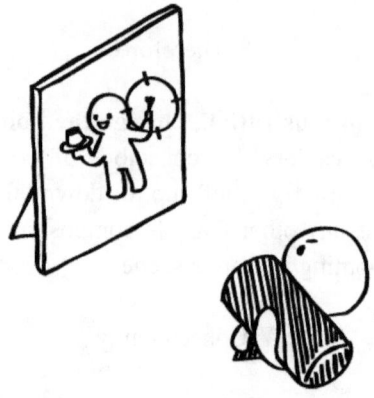

You have finished drawing a pattern illustration.

▼ In this context

You have a feeling of accomplishment and are satisfied with the illustration, but you overlook potential points of improvement. The process of developing a pattern illustration is long and exhausting. Therefore, once you finish drawing an illustration, you start to feel satisfaction that you have actually finished. In addition, since you put so much time and effort into the illustration, you start to feel affectionate toward it and blind yourself to its bad points.

▼ Therefore

Check your illustration again with the question, "Are any points strange and unnatural?" By now, your illustration should express the pattern quite precisely. But check for points of improvement—as a piece of drawing. Is the character using his dominant hand? Are his legs and arms bent in the right direction? For facial expressions, it is useful to draw a cross with a pencil based on the direction the character is facing.

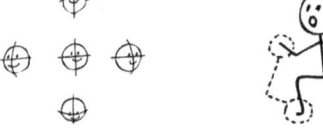

In addition, check for unrealistic points. Do the objects have their correct shapes? Are any objects just floating in the air? If you do not have any idea how to fix such problems, check *External Inspiration* to see specifics on how things are drawn.

▼ Consequently

The illustration's strangeness will be wiped out, and readers will be able to focus on its more important parts. In addition, working on the illustration's specific details will improve its quality. Such illustrations attract readers to the pattern and might even create fans of your pattern language.

▷ 23. External Inspiration

No.20

Simple Illustration

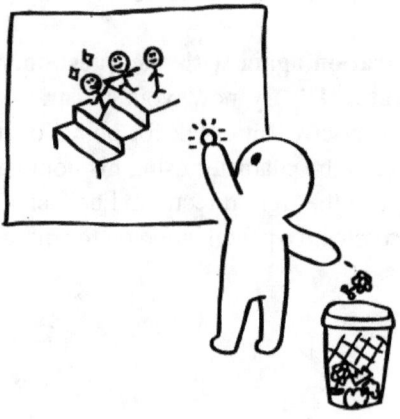

You have finished drawing a pattern illustration.

▼ In this context

If you put in too much information, readers will not be able to understand the illustration's message. You want readers to understand the pattern better with the illustration, so you put too much information into the illustration. Or you might feel artistic and put in too much decoration. Since first-time readers of a pattern will not know which parts of the illustration are important, excessive information will be negative for them.

▼ Therefore

Keep the amount of information in an illustration to a minimum. If anything in the illustration does not have direct meaning, take it out. Don't rely too much on decoration, and try to express a pattern's liveliness through the character's movements and expressions. Once you have taken out unnecessary parts, be sure to get a *Third Person View* to see if the illustration is still understandable.

▼ Consequently

By getting rid of the unnecessary, you will directly illustrate the pattern's main message, and readers will understand the pattern better. However, don't make your illustration so boring that it doesn't attract *Illustration Fans*.

▷ 21. Illustration Fans ▷ 24. Third Person View

No.21

Illustration Fans

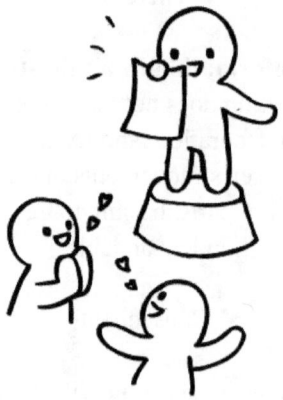

You have finished drawing your pattern illustration and also finished checking whether it is a *Simple Illustration*.

▼ In this context

You feel the illustration lacks something and is not attractive. If something is fun and exciting to look at, people will want to see it repeatedly. However, if an illustration is just plain and descriptive, it may convey the message correctly, but not move readers' hearts. This kind of illustration will not make readers want to practice the pattern.

▼ Therefore

Stand in the readers' shoes and draw an illustration that is attractive and fun to see. Imagine your audience and use characters that appeal to them. If you use *Acting Illustrator* to work on small details, the characters will come to life, and the illustration will be attractive. Draw with a playful mind and entertain the audience by making part of a pattern illustration from another pattern secretly reappear or draw a character doing something funny. Make readers want to be a part of the illustration.

▼ Consequently

The readers will enjoy your small, playful ideas, and your illustration will become more attractive as a result. With this kind of illustration, readers will be motivated to use the patterns more, or more people might become interested in your patterns. However, never forget to keep it a *Simple Illustration*, and never allow your playfulness to blind your readers to the pattern's core.

▷ 14. Acting Illustrator ▷ 20. Simple Illustration

Patterns for Assisting when You are Stuck

Nos.22 - 27

22 Intriguing Doodles
23 External Inspiration
24 Third Person View

25 Polishing Word Sense
26 Stock of Expressions
27 Improving by Drawing

No.22

Intriguing Doodles

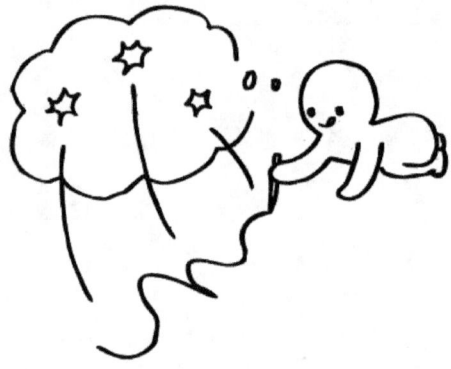

You are wondering what kind of a illustration to draw.

▼ In this context

You can't figure out what to draw, and your thoughts have just stopped. We tend to aim for perfection, and from the desire for perfection, we tend to perceive our ideas as bad. As a result, we run out of ideas, and our thought process stops. Once you reach this condition, it's hard to start thinking again without an idea to "spark" you from the outside.

▼ Therefore

Keep on moving your hand and doodle to generate ideas and get inspired again. This is a rough draft, and you're free to make mistakes. Try drawing out the vague image you have in your head or figure how that character should be moving. Draw anything that comes to mind and get inspired from it. Keep in mind that at this point, you are not trying to draw small details, but create an *Overall Rough Sketch*. Be sure to use paper you can use a lot of, like the back of paper that has previously been printed on.

▼ Consequently

By drawing out everything that comes to mind, you can externalize ideas inside your head. This will become a good source of inspiration, and you might be able to get new ideas.

▷ 5. Overall Rough Sketch

No.23

External Inspiration

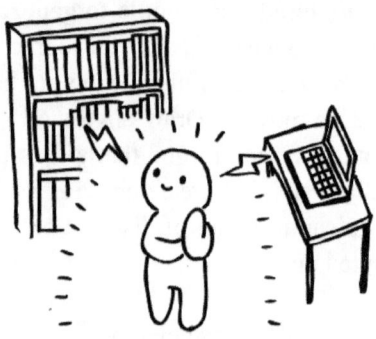

You are in need of some inspiration for what to draw for a pattern illustration.

▼ In this context

You try to think by yourself, but nothing comes to mind. There are limits to what you know and the ideas you can produce by yourself. You can't think about things you don't know. Even when you are familiar with certain things, not everything is stored in your mind.

▼ Therefore

Look at outside sources for ideas about what to draw. Use an online image search, or look through books with many pictures or drawings in them. If you do not have these sources, try asking someone close by for some ideas.

▼ Consequently

You will be able to get ideas that you would not have thought of by yourself, and from these ideas, you can draw pattern illustrations. These ideas themselves go on to become the source of even more ideas. In addition, by conducting an image search with a key word, you can learn what kinds of images people associate with that word. From this, you will be able to use the word with the *Word Association Game*.

▷ 8. Word Association Game

No.24

Third Person View

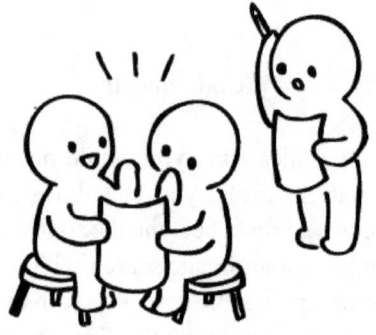

You have finished drawing a pattern illustration,
and you are somewhat happy with it.

▼ In this context

You want to improve the illustration, but you don't know how you can make it better. Since your project members already know much about the topic, they should be able to understand the illustration rather easily. Therefore, even if you think you want to make the illustration better, the fixed views you have are preventing you from finding points that might cause misunderstandings.

▼ Therefore

Show the illustration to someone unrelated to the pattern to get fresh ideas. Show only the pattern name and pattern illustration. Ask what the pattern is about and what the person thinks about the illustration. You will be able to see how others will receive your illustration and what points you should improve. You can even ask for specific advice.

▼ Consequently

You will be able to find points of improvement that you couldn't have found on your own and use *Strangeness Busters* to improve the illustration. In addition, by getting comments from people outside the project, you will get comments not only on the pattern illustration, but also on the pattern's content itself.

▷ 19. Strangeness Busters

79

No.25

Polishing Word Sense

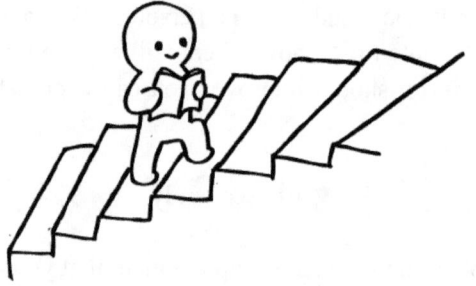

You want to become able to draw good pattern illustrations

▼ In this context

You have trouble looking for center words, recognizing their relations, and using metaphors to decide what to draw. It is not enough to understand only individual words in order to search for important words and phrases within a paragraph and to understand their complex relationships. You will have to understand the "temperature" and the "atmosphere" each word contains. In addition, to use metaphors effectively, you will need good analogical thinking, but this also requires an understanding of the vague images conjured by the words.

▼ Therefore

Consciously take time to polish your word sense by reading and writing in your everyday life. Read not only books from areas in which you are interested, but also from areas with which you are unfamiliar. To train your writing skills, you can also write in a diary or write letters to a friend. In addition, you might discover some words or expressions you like by listening to other people's words. Try using metaphors on a daily basis to raise your skills of *Word Association Game*.

▼ Consequently

You will become able to understand how words overlap to create a "quality" and see the true meaning behind the words. This skill is very useful in thinking how pattern illustrations can be improved. It will also become useful in thinking of better expressions for center words in a pattern and then for brushing up the pattern itself.

▷ 8. Word Association Game

No.26

Stock of Expressions

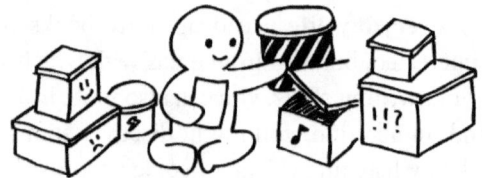

You want to improve your pattern illustration skills.

▼ In this context

It's hard to draw an illustration that expresses the atmosphere and meanings of a pattern so that anyone can understand it. As we encounter different expressions and put ourselves in different environments, we experience many different feelings. We are all used to "looking at something to get a certain feeling," but very few of us can "create an expression that will give a person a certain feeling." However, this is exactly the skill needed to become a good pattern illustrator.

▼ Therefore

Take notes and create a stock of expressions you encounter along with the feelings you got from them. For example, if you visit an art museum, write in your notebook your thoughts on the artwork you saw and the impressions you got. If you see an ad you like, search the Web or magazines for the story and the intentions behind it. Take time for some introspection when you are in the city or when you are surrounded by nature to see how you feel in that environment. Use your body to express your feelings.

▼ Consequently

You will be able to draw pattern illustration that will make readers feel the same way that you feel when you read your own pattern. Exposing yourself to a variety of expressions will polish your connections to your feelings and sensations in response to specific expressions. This should also make you better at *Acting Illustrator*, and you will be able to think of more expressions and movements. All these strategies will make you a more expressive pattern illustrator, who can move the audience with your illustrations.

▷ 14. Acting Illustrator

No.27

Improving by Drawing

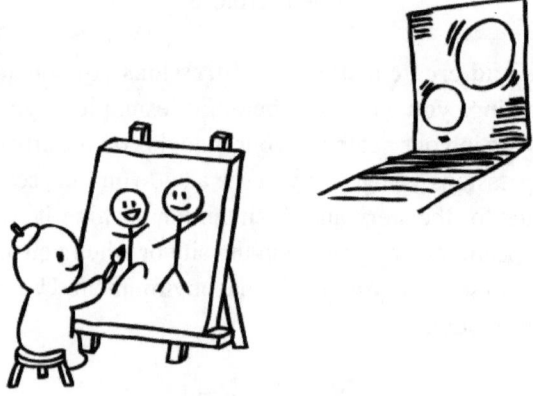

You want to become a better pattern illustrator.

▼ In this context

Even if you have sufficient experience with pattern illustrating, you still cannot draw an attractive, memorable pattern illustration that conveys meaning well. With much experience, your drawing skills will improve, and the process of drawing a pattern illustration will go more smoothly. However, since the contents of the pattern language differ every time, cheap tricks will not be enough to create good pattern illustrations. In addition, if the pattern itself does not have good quality, it is impossible to draw a pattern illustration with good quality.

▼ Therefore

Through the process of creating a pattern illustration, improve the verbal expressions of the pattern itself. The process of pattern illustration involves *Center Words Hunting* to find what to draw and also thinking about *Layout of Space* and *Lively Peak Capture* to draw a lively illustration. This process depends on center words, but they can always be replaced with better ones. As you try to capture a pattern's liveliness with an illustration, you will start to notice what you really wanted to say in the pattern. In such a case, go ahead and change center words and make the pattern's expressions better.

▼ Consequently

The pattern-illustrating process will change and improve the pattern's expressions. At first, you might think pattern illustrations are additive, and all you have to do is draw an illustration that correctly captures the pattern's meaning. However, once you have experience, you will notice that this is a process to make the pattern better—and even more, it is an important part of creating the pattern itself. By making the pattern better, you will be able to draw an attractive and memorable illustration that people will admire.

▷ 4. Center Words Hunting ▷ 10. Layout of Space ▷ 13. Lively Peak Capture

References

Alexander, C. (1979) *The Timeless Way of Building*, Oxford University Press, New York.
Alexander, C., Davis, H., Martinez, J. and Corner, D. (1985) *The Production of Houses*, Oxford University Press, New York.
Alexander, C., Ishikawa, S., Silverstein, M., Jacobson, M., Fiksdahl-King, I. and Angel, S. (1977) *A Pattern Language: Towns, Buildings, Construction*, Oxford University Press, New York.
Beck, K. and Cunningham, W. (1987) 'Using pattern languages for object-oriented programs', *OOPSLA-87 Workshop on the Specification and Design for Object-Oriented Programming*.
Furukawazono, T., Iba, T., with Survival Language Project (2015) *Survival Language: A Pattern Language for Surviving Earthquakes*, CreativeShift Lab.
Gamma, E., Helm, R., Johnson, R. and Vlissides, J. (1994) *Design Patterns: Elements of Reusable Object-Oriented Software*, Addison-Wesley, Boston.
Harasawa, K., Miyazaki, N., Sakuraba, R., and Iba, T., (2014) "The Nature of Pattern Illustrating : The Theory and the Process of Pattern Illustrating" the 21th Conference on Pattern Languages of Programs (PLoP2014).
Harasawa, K, Miyazaki, N., Sakuraba, R., and Iba, T. (2015) *A Tale of Pattern Illustrating*, CreativeShift Lab
Iba, T. (2011) 'Pattern Language 3.0 methodological advances in sharing design knowledge', in *the International Conference on Collaborative Innovation Networks 2011 (COINs2011)*.
Iba, T. (2012) 'Pattern Language 3.0: writing pattern languages for human actions', Invited Talk, in *the 19th Conference on Pattern Languages of Programs (PLoP2012)*.
Iba, T. with Iba Laboratory (2014a) Learning Patterns*: A Pattern Language for Creative Learning*, CreativeShift Lab.
Iba, T. with Iba Laboratory (2014b) Presentation Patterns*: A Pattern Language for Creative Presentation*, CreativeShift Lab.
Iba, T. with Iba Laboratory (2014c) Collaboration Patterns*: A Pattern Language for Creative Collaboration*, CreativeShift Lab.
Iba, T., Okada, M, with Iba Laboratory, DFJI (2015) *Word for a Journey: The Art of Being with Dementia*, CreativeShift Lab.
Lakoff, G. and Johnson, M. (1980/2003) *Metaphors We Live By*, University of Chicago Press.
Manns, M.L. and Rising, L. (2005) *Fearless Change: Patterns for Introducing New Ideas*, Addison-Wesley, Boston.
Pedagogical Patterns Editorial Board (2012) *Pedagogical Patterns: Advice for Educators*, Createspace, San Bernardino, CA.

Shimomukai, E., Nakamura, S., with Iba, T. (2015) *Change Making Patterns: A Pattern Language for Fostering Social Entrepreneurship*, CreativeShift Lab.

Pattern Language 3.0 Catalogue Series

Learning Patterns: A Pattern Language for Creative Learning
Takashi Iba *with* Iba Laboratory, 2014

Learning Patterns is a set of patterns that describe the secrets of creative learning. It offers 40 patterns, each of which captures an aspect of a good learning. Create opportunities for learning on your own by launching and implementing your own project, as well as learn by actively creating in collaboration with others!

Presentation Patterns: A Pattern Language for Creative Presentations
Takashi Iba *with* Iba Laboratory, 2014

Presentation Patterns is a set of patterns that describes the secrets of creative presentations. There are 34 patterns, each of which captures an aspect of a good presentation. Treat your presentation not as merely a chance to explain your idea, but as a chance for creation. Work with your audience to trigger new findings in them!

Collaboration Patterns: A Pattern Language for Creative Collaborations
Takashi Iba *with* Iba Laboratory, 2014

Collaboration Patterns is a set of patterns that describes the secrets of creative and collaborative project work. Each of the 34 patterns captures an aspect of a good collaboration. Create new values that can change the world by collectively producing an emergent synergy that cannot be reduced to any one team member, but can only come from developing the capacity to enhance each other!

Words for a Journey: The Art of Being with Dementia

Takashi Iba and Makoto Okada (eds.), 2015
Iba Laboratory and Dementia Friendly Japan Initiative

Words for a Journey collects practical knowledge on living with dementia. Though many hold negative impressions of the disease, there are still many who are living well with dementia. This book collects wisdom and stories from such people, and extracts its essence to be shared widely.

Survival Language: A Pattern Language for Surviving Earthquakes

Tomoki Furukawazono and Takashi Iba
with Survival Language Project, 2015

Survival Language is a pattern language to improve survival rates when a catastrophic earthquake occurs. There are twenty patterns, each of which captures practices of Designing for Preparation, Designing for Emergency Action, and Designing for Life After a Quake that form patterns found in the many lessons Japan has learned from numerous earthquakes.

Change Making Patterns: A Pattern Language for Fostering Social Entrepreneurship

Eri Shimomukai and Sumire Nakamura
with Takashi Iba, 2015

Change Making Patterns is a set of patterns that describe the secrets for creating social change. There are 31 patterns, each of which captures the aspects of creatively solving social issues. Launch your own change-making project to tackle social issues in your own context to take part in creating a better world!

A Tale of Pattern Illustrating

Kaori Harasawa, Natsumi Miyazaki, Rika Sakuraba and Takashi Iba

The theory and practice of Pattern Languages have widely spread, and pattern languages for creative activities are created in various domains. One day, a guide from the world of pattern illustrations has appeared in front of a little boy who is writing a pattern. With the help of the guide, the little boy meets many villagers of the world of pattern illustrations and develops his understanding of the importance and excitement of drawing pattern illustrations. This tale invites you to understand what pattern illustrations are and how to draw them.

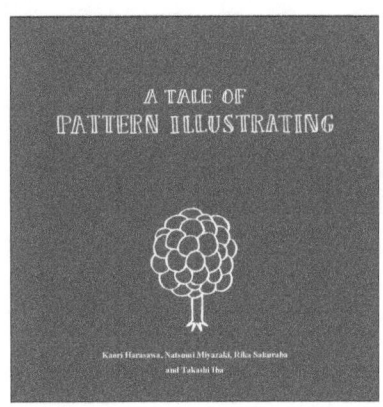 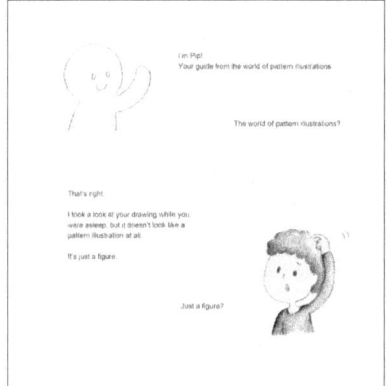

ISBN 978-1-312-94108-3
Full color Perfect-bound Paperback
Publisher: CreativeShift Lab, 2015
Available on Amazon.com

Pattern Illustrating Patterns

0 Pattern Illustrating

1 Essential Message
2 Moving Characters
3 Symbolic Representation

4 Center Words Hunting
5 Overall Rough Sketch
6 Sketches of Details

7 Image of Motion
8 Word Association Game
9 Deciding the Amount

10 Layout of Space
11 Instinct Direction
12 Zooming Out

13 Lively Peak Capture
14 Acting Illustrator
15 Time Symbol

16 Mood Unity
17 Consistent Story
18 Composition Differentiation

19 Strangeness Busters
20 Simple Illustration
21 Illustration Fans

22 Intriguing Doodles
23 External Inspiration
24 Third Person View

25 Polishing Word Sense
26 Stock of Expressions
27 Improving by Drawing

www.ingramcontent.com/pod-product-compliance
Lightning Source LLC
Chambersburg PA
CBHW072224170526

45158CB00002BA/738